How to Draw an Eye

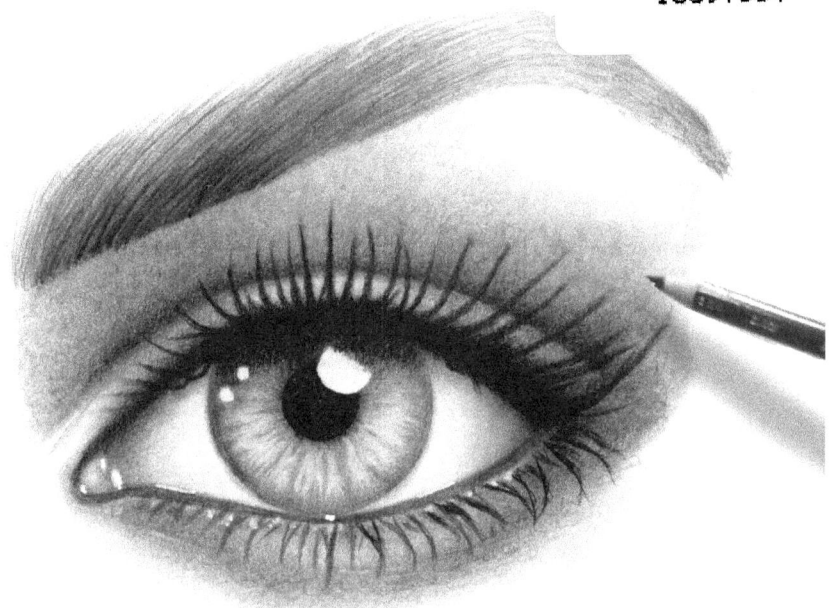

By Jasmina Susak

Copyright © 2019 by Jasmina Susak

www.jasminasusak.com

Text and artwork © Jasmina Susak
Page layout and cover design by Jasmina Susak

All rights reserved. No part of this publication may be reproduced, distributed, or transmitted in any form or by any means, including photocopying, recording, or other electronic or mechanical methods, without the prior written permission of the author. For permission requests, contact the author via email:
jasminasusak00@gmail.com

More tutorials at:
WWW.PENCILDRAWINGTUTOR.COM

This book is dedicated to my cats.

*Being a painter means spending a lot of time
between four walls, far away from people.
My cats have been a perfect companion
on my journey of being an artist and art teacher.
I am so grateful for being allowed to travel with
these little creatures through space and time
on this big, round, spinning spaceship.*

INTRODUCTION

In this tutorial, I'll show you how to draw a photorealistic eye with graphite pencils. I'll show you how to create a proportional sketch completely from scratch, how to highlight and shadow to give your drawing depth, and how to draw the smooth texture of the skin.
So, let's draw!

TOOLS

For this tutorial, you will need a high-quality paper and a few pencils. You should try out the brands of paper and pencil to see which ones work for you. I can only say what I use and why, so that you can try these too.

I have been using the paper by Fabriano Bristol, A4 format (210 x 297 mm -- 8.3 x 11.7).

I'll be using a couple of pencils, Castell 9000 by Faber Castell.

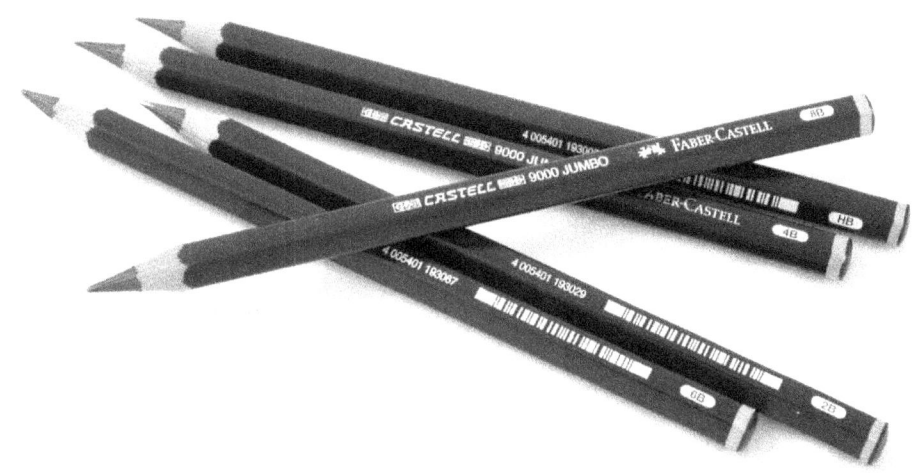

Eraser in pencil, also by Faber-Castell.

I will be using a blending stump, q-tips for blending, and a white marker by Uni Posca for additional highlights.

DRAWING TUTORIAL

Let's start with a circle. Create the iris boundary with a divider tool to make the circle perfectly round. The distance between the needle and the pencil tip on my divider tool is 2 centimeters or 3/4 of an inch; so the diameter is a bit more than one and a half inches or 4 centimeters, if you want to draw the same size.

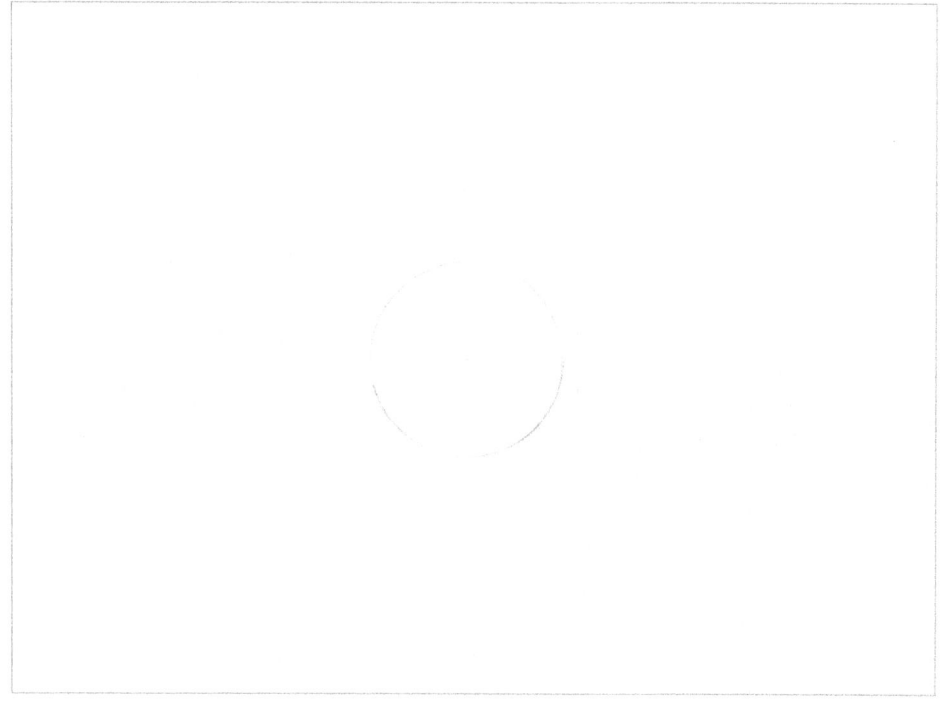

Keeping the needle in the same place, reduce the distance between your needle and the pencil tip to the distance that you want to draw a pupil

boundary. In my case, it's about seven millimeters or 1/4 of an inch.

Now take the measurement that you used for the iris boundary from the center of the iris to the left or right side of the iris boundary, which is 3/4 of an inch, or two centimeters, and then place the needle on the left side of the iris boundary, and mark a short vertical line, which will represent the edge between the white of the eyes and the tear duct. Do the same on the right side, keep the same measurement on your divider tool, and mark the outer corner of the eye on the right side.

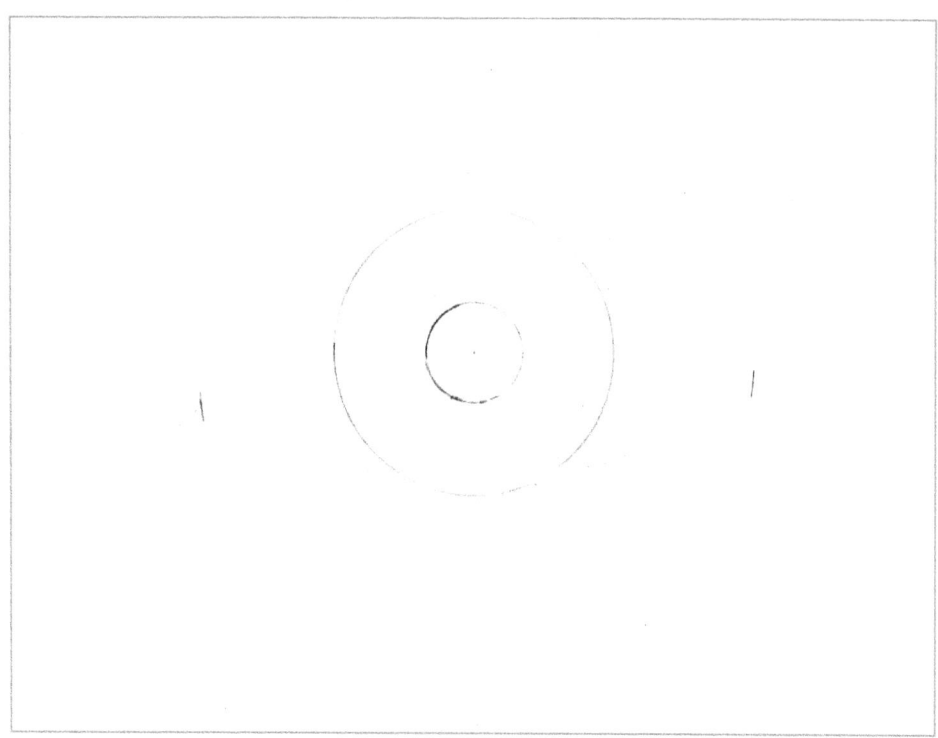

Now we can outline the eye. I use an HB for this. Start with the lower outline, right under the iris boundary, and just follow along a bit of the iris boundary horizontally. Then start to divide from it; draw a dotted or dashed line first to see how it will connect. When you make sure it will connect good, draw the full line, but don't press too hard. Do the same on the left side; follow the line of the iris boundary, and start to separate them and finish on the marked line. Draw the tear duct too. It can be round, or it can be an ellipse.

Now, let's outline the upper eyelid. It should be placed under the upper part of the iris boundary, in the middle between the iris boundary and pupil boundary. Start with a short horizontal line in the middle, and start curving it downwards, towards the tear duct, and connect it to the upper part of the tear duct. You can always improve on the outline, if you don't like it. Do the same on the right side; follow the horizontal line that you just created in the middle, and start curving it downwards, toward the marked point. Draw the visible thickness of the skin of the lower eyelid.

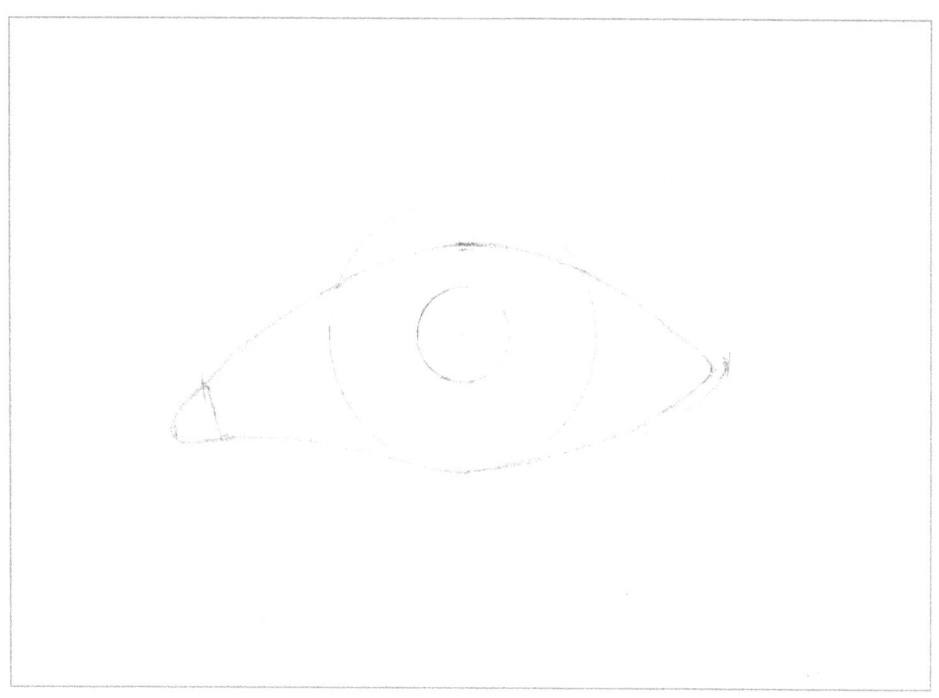

Now we can erase the part of the circle, above the upper eyelid, under the crease and actually, let's create that crease. It should be a curved line, parallel to the upper eyelid that we just outlined. Just follow the upper outline of the eye. You can make it a bit farther, or closer to the eye, if you want.

Also, outline the eyebrow. When you sketch the eyebrow, create a dashed line, and don't draw them with a full line, and don't press too hard. I want to create a female eye, so I want to have an arched eyebrow laying over the highlighted part of the face, next to the temple. You should make it a bit thicker right above the tear duct, and it'll be thinner as we approach the temple. Something like my eyebrow that you can see in

the next image. We can always change the outline if we don't like it.

Before we start coloring the iris and the pupil, let's just determine the position of the reflected light. I want to make one that goes over the iris in a round shape, but it can be any shape. I want to draw one above the pupil, covering the upper part of the pupil a bit, and I want to make two smaller dots on the left side, as shown in the next image. Erase the part of the pupil boundary that you don't want to have over the reflected light.

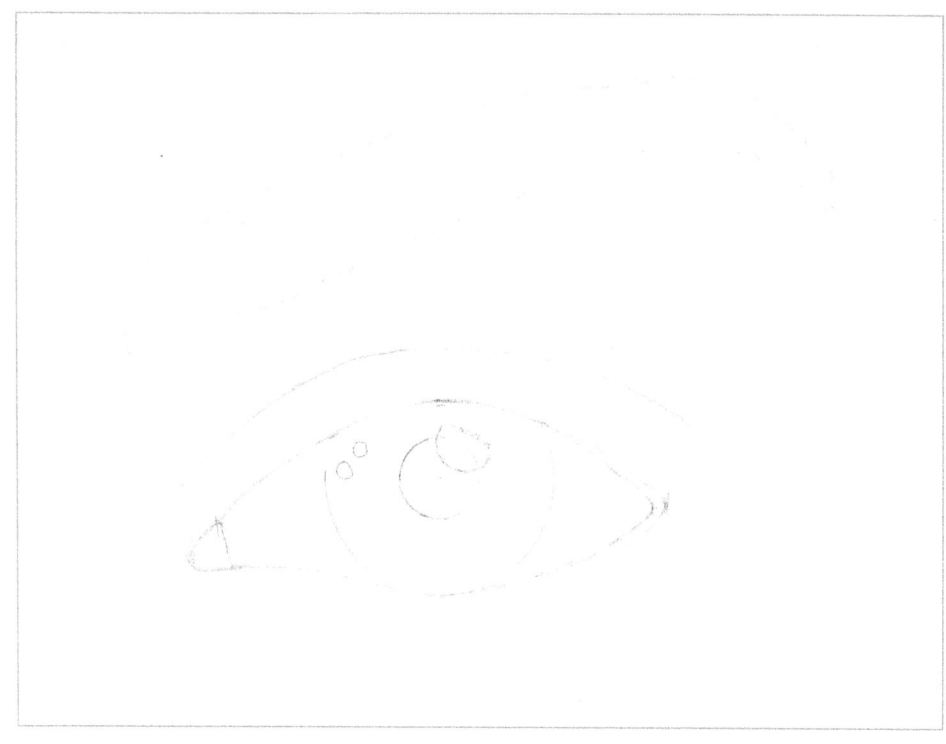

It's time to fill the pupil with the darkest pencil that you have. I'm using an 8B pencil for filling the pupil in a circular motion. This pencil is very dark, just press hard and fill in the whole pupil, except inside the reflections. Make sure to keep the outline sharp and the circle perfectly round. Don't be afraid of using a very dark pencil; It'll give depth and life to your eyes. I mean, you can't really get *this* black color with an HB or brighter, so it's very important to have this absolutely black.

Now, let's draw the iris boundary. I'm using an HB for this, and I'm just drawing all around within the circle, next to the edge, about one or two millimeters deep. This is kind of the iris boundary, not every eye has this boundary, so you can skip it actually if you want, but it always has kind of a darker color than the mid area of the iris. A pencil darker than an HB would be too dark for this, so we should use an HB or brighter. If you are using an HB, like me, just make sure to press a bit harder. Also, if you have any reflections covering the iris boundary, just skip over them and go all around them carefully. Try not to go over the whites of the eyes.

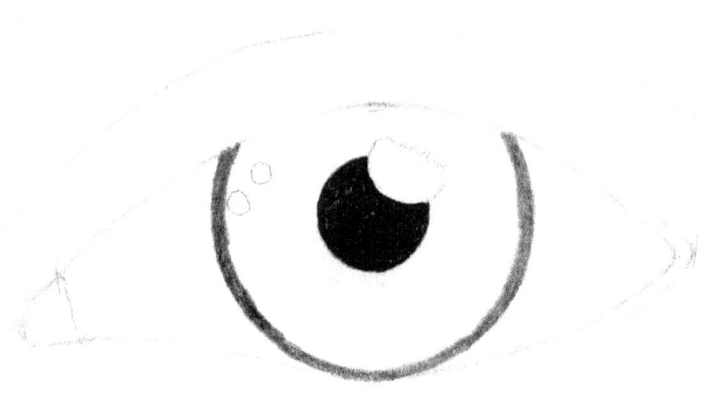

Before we start to color in the iris, let's just blend the outer area that we just created, with a blending stump to make the outer edge of the iris boundary blurry.

So, the edge between the white of the eye, the so-called sclera, and the iris boundary.

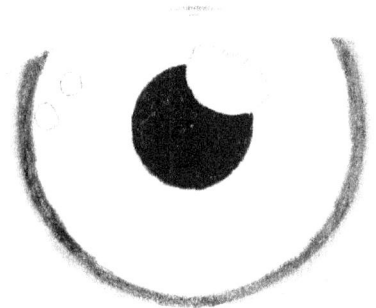

In this step, create the shadow that the upper eyelid cast over the iris. I used an 8B for this. I recommend using darker tones because drawing pale drawings is very difficult and the darker tones will produce better results than pale. Of course, the tone of the shadow will depend on which color you want your eye. So if it's a blue eye, the shadow should be brighter than the shadow cast over the brown eye. I actually want to draw a female eye that would have some makeup, so this shadow will be darker because of the mascara, and we just have to make it a bit darker in the upper area. Skip all of the reflected light, don't draw over that at all; they should stay absolutely white. Cover the iris all along the whole width covered by the upper eyelid.

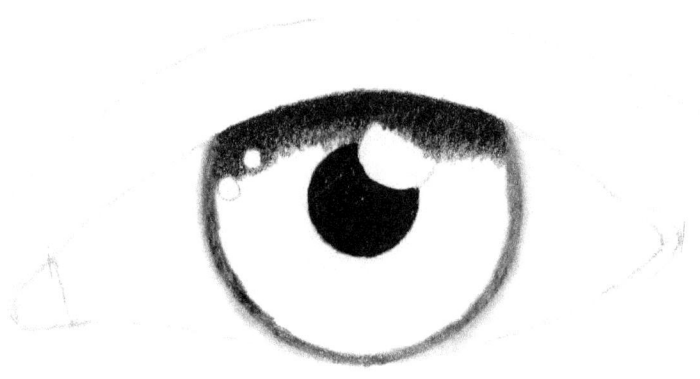

Now we can draw the spokes within the iris, following the direction of these arrows.

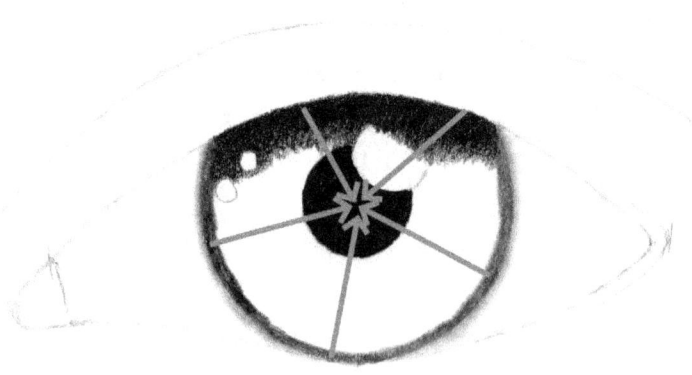

So, each spoke should radiate from the center of the pupil. You can use an HB, and don't press too hard. You can always add more if you want later. As always, skip the reflected lights. Press harder in the upper area because this part is less illuminated than the lower area. In the lower area, shade with less pressure and keep the strokes radiating from the very center. Check the previous image with those arrows all the time, if you need to.

You shouldn't rush. Just take your time. If your hand hurts, stop and you can continue tomorrow. You don't have to draw all of this in one sitting.

Now you can see how it starts looking like a real iris, but we're not done just yet. Don't worry if some of the spokes are darker than the others, it's fine. What's more, it's even better if it has some variations than if everything looked the same, that would be odd and not nearly as realistic. If everything is flat and without any imperfections, it would be cartoonish and lifeless.

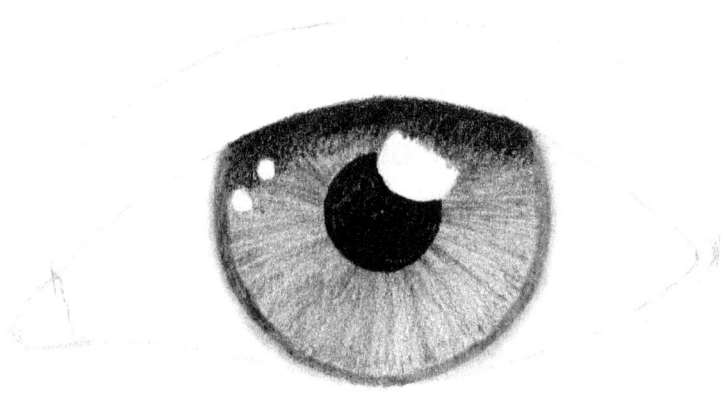

Blend this all with a Q-tip.

Don't go over the reflected lights, not even over the pupil because you can eliminate a lot of the graphite and it wouldn't be that black anymore.

But if you do so, you can just apply a very dark pencil again.

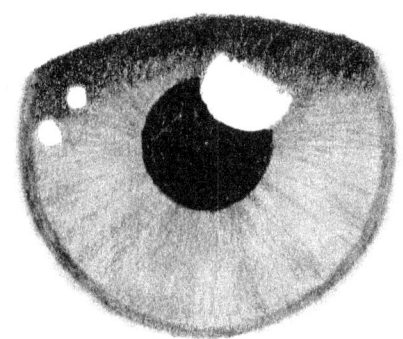

When blending next to the reflected lights, use a blending stump since you can blend more precisely.

Now you can create highlights over the iris with an eraser. Erase the mid area of the iris, and you can draw some patterns, or you can just remove the graphite, but don't press very hard. Place the tip of your eraser in the middle, and then move out towards the pupil and towards the iris boundary. This way, you will get brighter highlights in the middle of the iris. when highlighting close to the upper eyelid, press less and less. This highlight should be gradually disappearing into the shadow.

So, press very lightly and gently with an eraser.

The iris is always more highlighted in the lower area, so press harder with your eraser, if you want to make a brighter highlight. You can use a kneaded eraser, if you like that one. Or any other kind of eraser that works for you. If you erase too much, you can just go over it with your Q-tip or a blending stump to darken the highlight. So, don't worry, you can always change something and improve it.

This highlight shouldn't be the same everywhere. Try to create some randomness; you can skip some areas, you can make diagonal lines, or anything, just try not to make it all look the same because this randomness is what's going to make your eye look more realistic and lifelike.

Create the highlights all over the iris, except for the shadow cast by the upper eyelid. This area doesn't require highlights, or just a little bit right over the horizontal line which goes right through the center of the pupil. I mean, imagine this line, we haven't drawn that.

The lower area requires a brighter highlight and, of course, skip some areas and leave them untouched. When you use your eraser, press

harder when you want it brighter, and press less and less to make the highlights disappear into the basic color of the iris.

You can create some lines, patterns, dots, anything goes. There are so many kinds of irises that you really can't mess up here, but if you don't like something just erase it, or cover it up again. You can add more highlights later.

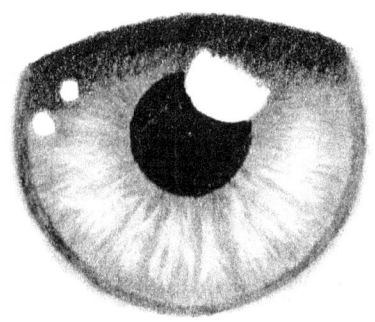

This iris looks pretty flat now, so we still have to shade the area between the iris and the pupil to make it look like the iris bends inwards.

To do that, use a 4B or darker pencil (I use an 8B), place the tip over the edge between the pupil and iris, and just draw short, tiny lines towards the iris boundary. Of course, some of them should be a bit longer, some of them should be shorter, but they're all pretty short. Press very hard next to the pupil and release the pressure as you work towards the highlighted areas of the iris.

Now you can see in the next image, it already looks less flat and looks bent inwards. Do it this way if you're afraid of pressing hard. Do the same thing all around and of course skip any reflected light.

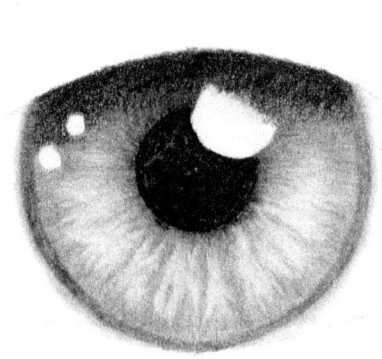

Now, let's do the same thing, but from the opposite direction and we'll be done with the iris.

Use an HB, press over the iris boundary and draw tiny short lines towards the pupil to make the iris boundary actually disappear into the iris, to make the edge between them invisible.

Draw these tiny strokes, following those arrowed lines that I showed you. You can draw some longer strokes towards the pupil to create the patterns over the iris and among the highlights that we created.

You can make some patterns this way, if you want. In this step, we're focusing on eliminating the edge between the iris boundary and iris.

Go all around and press harder in the upper area. Blend it a bit with a blending stump. Sometimes it's enough if you just stipple over the edge.

You don't have to press very hard at once, just go over the same area multiple times, stippling, and you'll achieve the same effect.

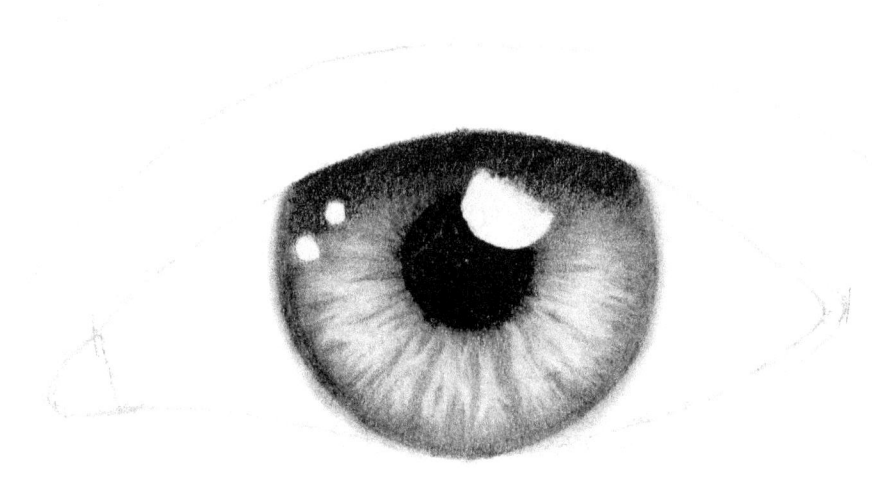

You can see how it now looks more realistic now. When you've drawn a bit, just blend it.

So, you can always darken or lighten up something, and we're pretty much done with the iris, but we can make any changes we need to later on.

As I mentioned, I want to draw a female eye with makeup. I want to draw eyeliner, a thick line right above the outline of the upper eyelid, using an 8B. If you don't want to draw make-up eye, use an HB in this step and also cover the thick area as shown in the next image. I just think it'll be easier for you to draw darker drawings because pale drawings are very difficult to draw.

So, you should definitely work with darker colors and don't be afraid of using them.

Create a thicker line as you are working towards the outer corner. Now you can see how that reflected light appears even shinier as I have added this very dark area all around.

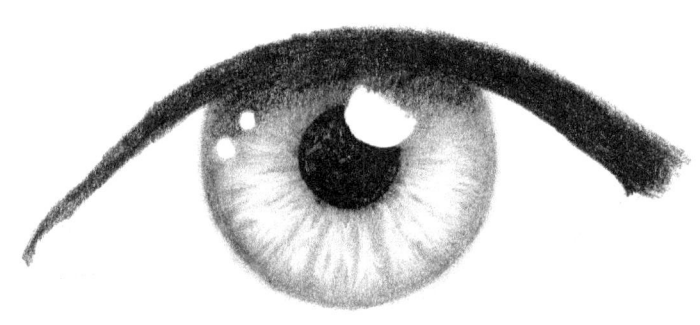

Now, let's shade the sclera, or the white of the eye. Skip the tiny areas between the tear duct and the whites of the eye; just leave tiny areas for the highlights. These should stay absolutely white.

When shading such delicate parts that have to be evenly toned, it's important to use a circular motion. I'm using an HB for the darkest part of

this shadow, which will be placed right under the upper eyelid. Even if you don't draw this eyeliner, and you want to draw up for example a male, also press harder using an HB because this is a well shadowed area and it should be darker.

So, the whites of the eyes should be shaded in whole, only the reflected light should be absolutely white. Here we have to make a gradient transition since the eyeball is round and we have to suggest that by creating a gradient transition of the gray tones, starting next to the tear duct, and shading towards the iris, pressing less and less.

Don't forget to shade the tear duct and make sure to leave some areas for the reflected light, or you can even add that later with a white marker, or a white ink gel pen. Press harder over the edges, and less in the middle the center of the tear duct should be brighter.

Keep using a circular motion, it's good for the smooth texture and press very hard next to the edge between the tear duct and the sclera to suggest the depth and roundness.

This area gets less light than the sclera next to the iris. If you create a darker area around the highlight, you'll enhance the highlight this way.

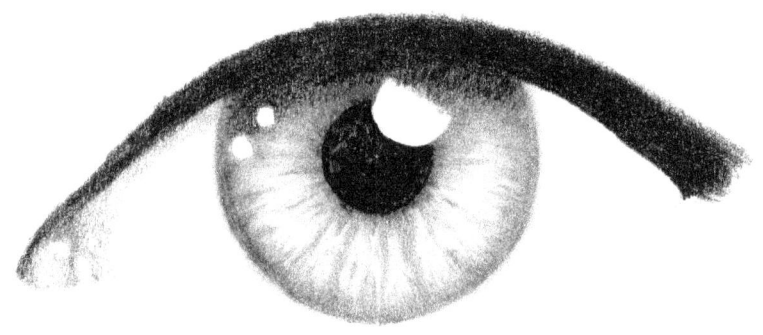

Blend this a bit with a Q-tip, also using a circular motion and try not to go over the highlights.

You can even use a blending stump next to the highlights, because it has a smaller tip and you can control that in such small areas, but chose one that you haven't used for blending before.

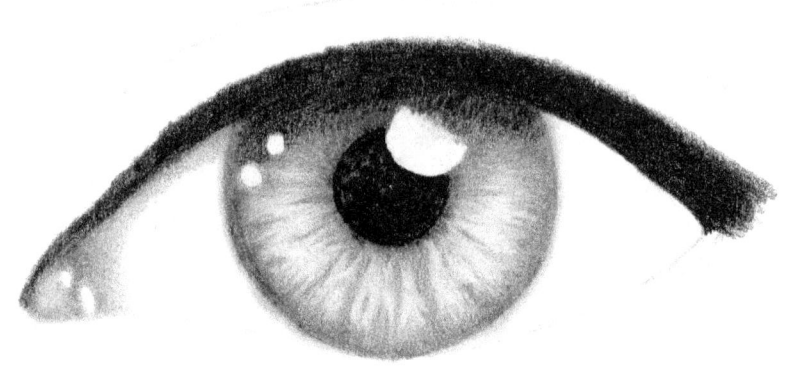

Continue with a brighter shade. I'm using a 2H for this, as a continuation to the HB area.

Draw tiny, overlapping circles, just avoid pressing hard because this 2H can also make pretty dark tones if you press harder, but you can use a 3H or 4H if you have those.

Shade about one-third of the width between the iris and the tear duct, just cover this whole area with your 2H. I don't really use anything over a 6H. Those pencils are very hard and they'll just scratch the paper. For bright areas like this, I'd rather use a blending stump.

Press harder next to the HB and just release the pressure as you shade towards the iris in order to make a gradual transition, to make this eyeball look round. Blend it a bit with a Q-tip, use a new one, certainly not the ones that you already used for shading.

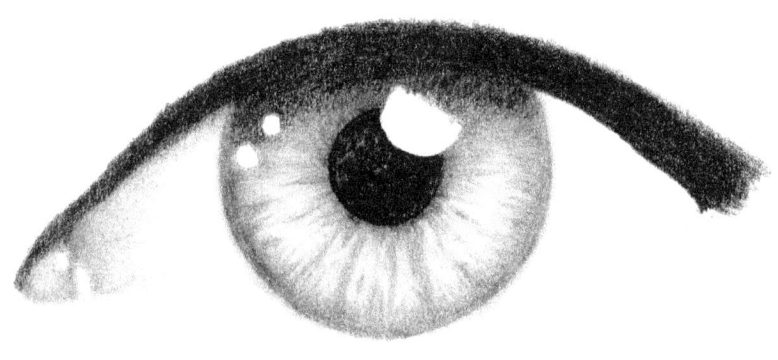

Use a 5H to cover the rest of the area, next to the iris boundary. This part also shouldn't stay white, but it should be much brighter than the previously shaded area. The area next to the iris should be the brightest, but yet it shouldn't be absolutely white.

Here also you want to keep applying in a circular motion and press harder next to the previously shaded area, and also go over it a bit. If you need more shade, you can always add more.

You should step away from the drawing to see it from a distance; only then you can see whether the gradient transition is good or not.

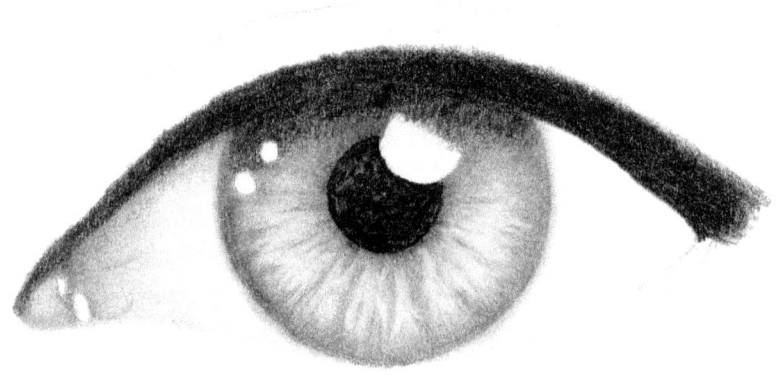

We can move to the right side, to do the same, but of course, create a gradient transition from the opposite direction.
Start on the right side, in the corner, using an HB and also, using a circular motion. This area should be darker because here we have denser

and longer eyelashes. So, this area should be shaded more because it gets less light. An HB is a good pencil for this. Don't use anything darker than this one for shading this sclera because it has to look bright, shaded white, and darker pencils are just not good.

Make thick shadow cast by the upper eyelid. Press harder next to the upper eyelid, and then press less and less as you shade downwards. Use a blending stump to blend this, the one that has quite a lot of graphite on its tip. To blend the edge between the eyelid and sclera, use circular motions and go over it with a B or darker pencil.
If the cast shadow turns out a bit darker, just remove a bit of the shade with the clean Q-tip.

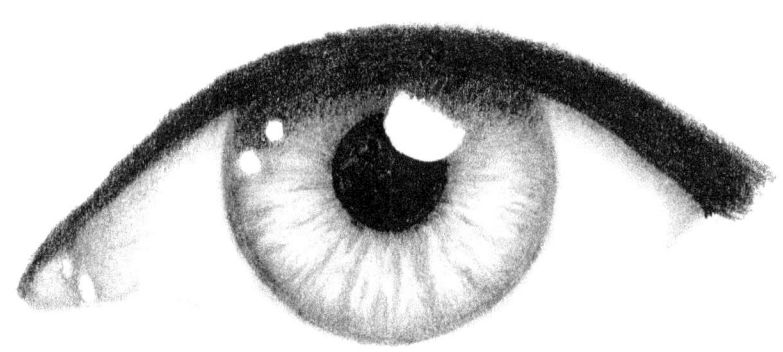

Continue to shade the brighter area with a 2H, in the same manner that we did on the left side. In a circular motion, pressing hard next to the dark shadowed area, and releasing the pressure as you draw towards the iris.

Blend it a bit and continue shading. You can also add some veins here or any other imperfections, and here we can also have some shadow cast by a single eyelash, or a group of eyelashes, but make it blurry by blending.

So, anything goes, but of course, it's a delicate part of the drawing so do it carefully.

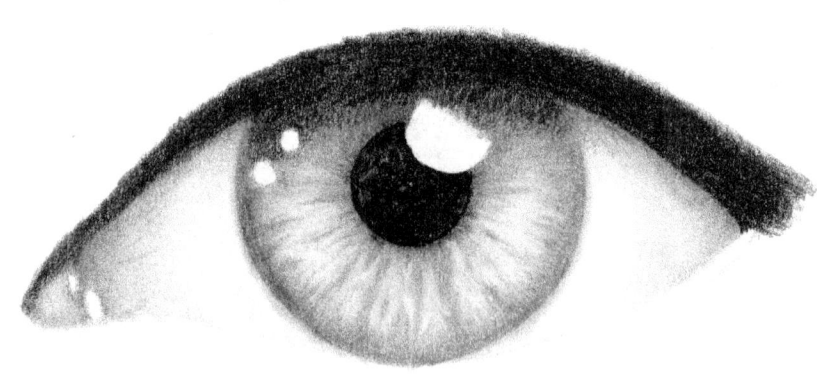

Finish shading with a 5H next to the iris, just the way we did it on the left side. Apply tiny overlapping circles, pressing very gently, hardly touching the paper.

As I mentioned before, we shouldn't leave it white. Use a clean Q-tip and blend it and see if you need more shade, so that you can add more. In the next image, you can see how it actually looks much more realistic than when it was all white. This is where beginners make mistake because they are afraid of using tones darker than they should be use.

Apparently, the sclera is white, that's why they think they shouldn't shade it. But even the absolutely white objects have self-shadow and the shadow cast over them, which is nothing but white.

I know, this is very difficult to draw, but try to practice this gradient transition on a separate piece of paper.

Do a lot of practicing before you actually start applying it to the drawing, and you'll be more confident and you'll know what will happen. I always keep repeating and explaining how to create this gradient transition because that's really the most important part of any drawing if you want it to be photorealistic.

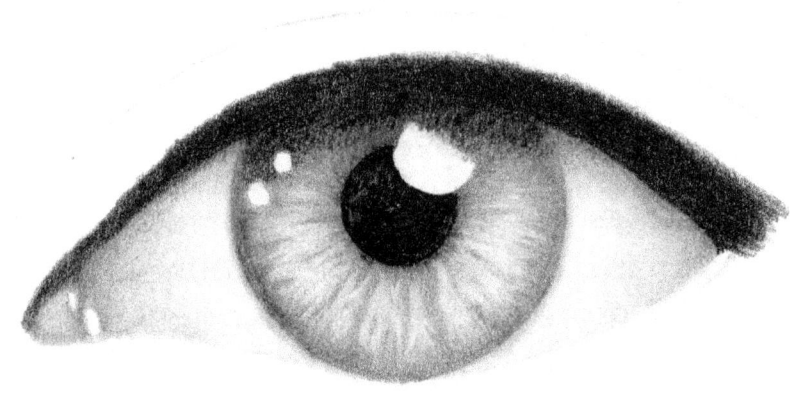

Now we can shade the area under the eye.

I pressed very hard, using an HB to color the thicknes of the skin, which is found between the roots of the eyelashes and sclera/iris. I wanted to make this look like cohl eyeliner, to make it more spectacular, and you can see how actually these dark colors will give depth to our drawing.

Blend the edge between the thickness of the skin and the sclera. If you don't want your eye to have makeup, you can just use a 4H or 5H, or even just a blending stump. But if you take a look at that from a distance, you'll see how pale these shades will be. I mean it's not that

enjoyable like when you made these heavy tones and shadows and, in my opinion, it's easier to draw, and nothing bad can happen, you can always start a new drawing if you don't like what you've created. Also, you can always erase something if it's too dark.

Make it a bit thicker in the area under the tear duct and just blend the edge with a blending stump. In the next image, you can see how the white of the eye actually has depth now, much more than there was before we applied this dark tone over the thickness of the skin. You can also see, how the reflected lights are very bright compared to the surrounding areas, and this makes the eye shine even more.

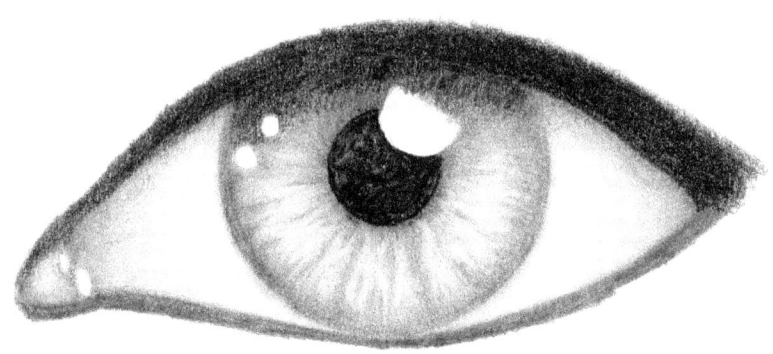

If you're satisfied with all this, you can move to shading the skin, which is, in my opinion, a more difficult part of the drawing. But, of course, it's all relative.

The first thing is to strengthen the crease with a B pencil. Make one thick line on top of your sketched outline. The bent skin gets less light, or it gets no light at all, so it should be shaded completely.

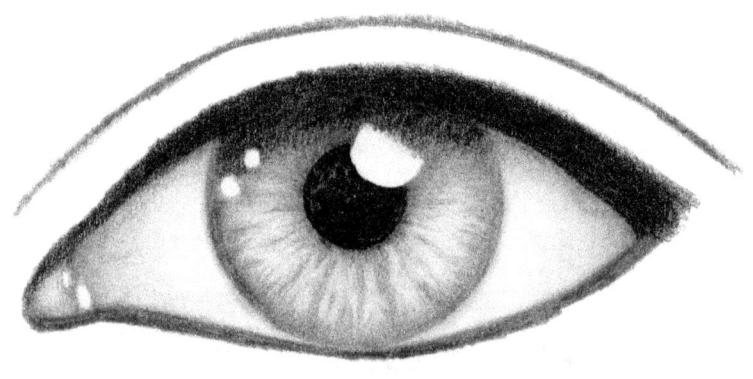

Let's divide this job into two parts. The first part is to shade the area between the eye and the crease, the second part will be shading above

the crease. These two parts have different shapes, so let's focus on one area at a time.

I use an HB for the areas that get less light. It should be highlighted in the middle. Press harder next to the eyeliner, or the edge between the eye and the upper lid, and release the pressure as you shade upwards.

Try to make that gradient transition and just shade it all in a circular motion. Maybe you're wondering why don't we draw the eyelashes already. Well, we're going to draw them after the skin is done. If we draw them now, we would have to shade the skin around them, and it would be more difficult that way. We could mess everything up and end up drawing over the eyelashes so that wouldn't be good. It'll just be much easier to add them once the skin is shaded and completed.

Take a look at the next image to see the areas that I have shaded in this step. These areas, on the left and right sides of the highlight, are less illuminated so it should be shaded more. To explain it simpler, the skin above the iris is untouched, and I have shaded the skin above the sclera on both, left and right sides.

An HB is pretty good for the skin. Even if you press very hard, an HB is going to suggest the bright color of the skin than if we were to use a B

or darker pencil. You can press harder next to the dark areas to create a gradient, and you press less in the middle. You can create a lot of tones with this one pencil, so that's why I love this HB.

Blend it all to impress this graphite into the paper, and then just shade it more with a pencil, if necessary. It should be shaded more around the crease because this area is less illuminated.

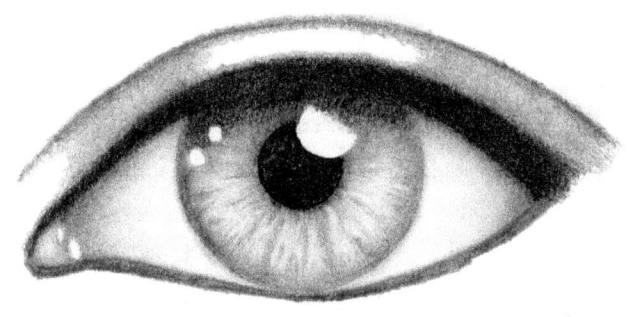

Make it a bit brighter skin in the middle because it shouldn't stay absolute white.

The skin over the eyeball should also suggest the roundness of the eyeball. Don't worry if you

make it too dark, you can always get rid of some of the graphite with an eraser.You should practice a lot because you'll truly learn through making mistakes.

Use a 2h for mid area and keep drawing in a circular motion. Press harder next to the shaded areas, and press less in the middle.

Blend it a bit with a Q-tip and it will appear quite brighter than the left and right sides. If you use a clean Q-tip, you can brighten the areas, so you can always change anything.

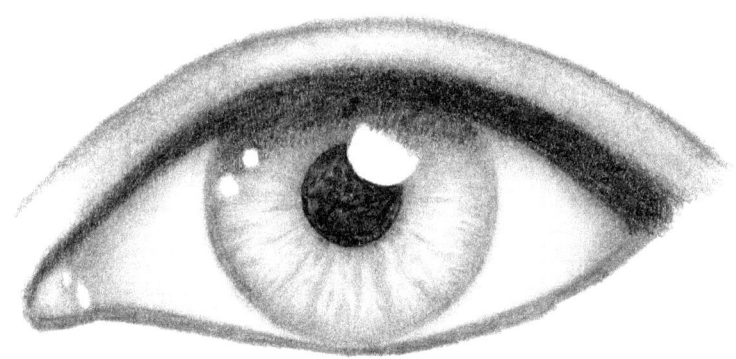

Shade the area above the crease. But before that, strengthen the lower outline of the eyebrow, so that you can see where it is because we're going to shade this area too.

Shade the darkest parts first, using a B pencil and circular motions. Press very hard next to the crease and release the pressure as you draw towards the eyebrow. So, an HB is pretty bright here, we need a darker pencil. A B pencil is pretty good, just keep applying a circular motion above the crease, all along it. You can make one bigger shaded area above the right corner than in the middle, right above the highlight.

Study next image to understand which area to shade in this step. The area above the tear duct should be much darker than the area next to the temple because this area gets less light.

As always, blend it all a bit with a Q-tip.

You will see, as you are blending over the crease, it'll become brighter and brighter, although you used an 8B. That's why I suggested not to be afraid of using darker pencils. Add a bit of an 8B again over the crease, if necessary. Or maybe at the end of the drawing, as a final touch when you see the whole drawing done.

When you shade towards the left side, shade with less pressure, but also try to make it pretty dark. This whole step will take more time, but it's really worth it because it'll give the skin a smooth texture.

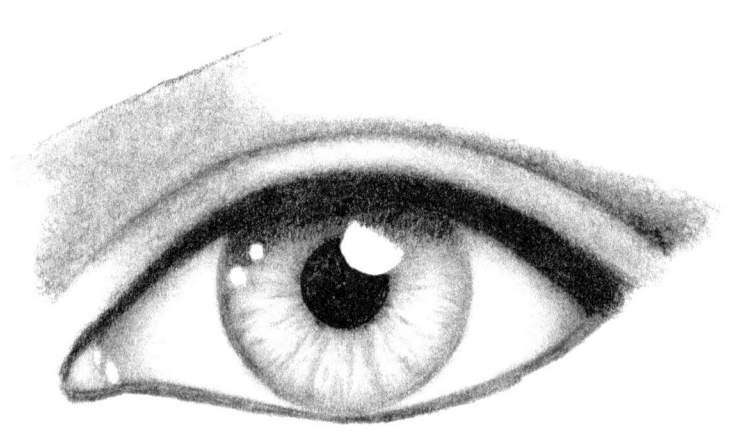

Now you can shade towards the temple and start using brighter tones because we have to create a gradient transition.

Use a circular motion, an HB pencil. Use an HB next to the area shaded with a B, pressing harder next to it, and release the pressure as you work away from the darkest shade, as you

draw towards the highlight. The highlight is the brightest under the arch of the eyebrow, next to the temple. Of course your eyebrow doesn't have to have this curved shape. Yours could be straight, it can have any shape.

Also, shade above the crease, above the previously shaded B area as a continuation to this. The gradient transition from the crease to the eyebrow is very important because this area has a round shape. Blend it a bit with a tissue to impress the graphite into the tooth of the paper.

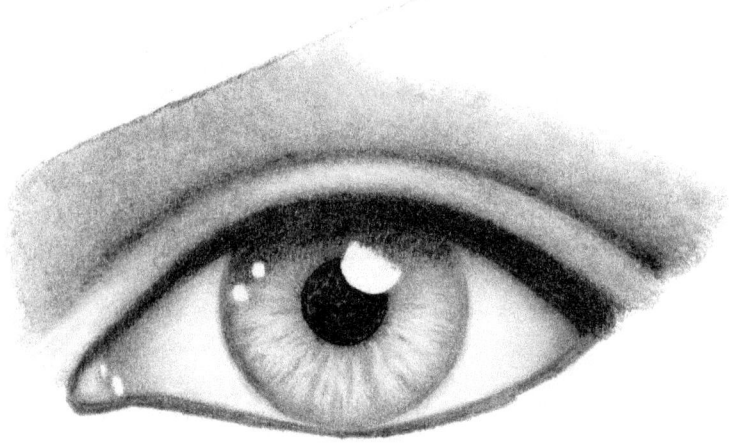

For the next step, as a continuation, draw with a 2H or 3H next to the HB pressing a bit harder, but not too hard.

Circular motions, same as we've been doing, pressing harder next to the previously shaded area, and releasing the pressure as you draw towards the highlight. And the same here, we want to make our gradient transition as flawless as possible. Some imperfections are okay, but avoid making lines because that's not good if they're visible.

The tip of this H pencil should be dull and not sharp at all. You shouldn't sharpen it at all. You can use it a lot without sharpening. And when you do sharpen it, just make it dull again before you use it because its sharp tip won't do anything except scratching the paper. That's not good, particularly when we shade the bright skin. The duller the tip, the better.

You can see now how it starts to show a round shape. Use a clean Q-tip, namely, don't use a Q-tip that you used for blending, particularly not a B or darker pencils.

Do not use dirty Q-tips for blending these areas because it'll apply that graphite here and that's not what we want.

You can even use a tissue. Shade a bit the area next to the temple, so that you have untouched circular area under the arch of the eyebrow.

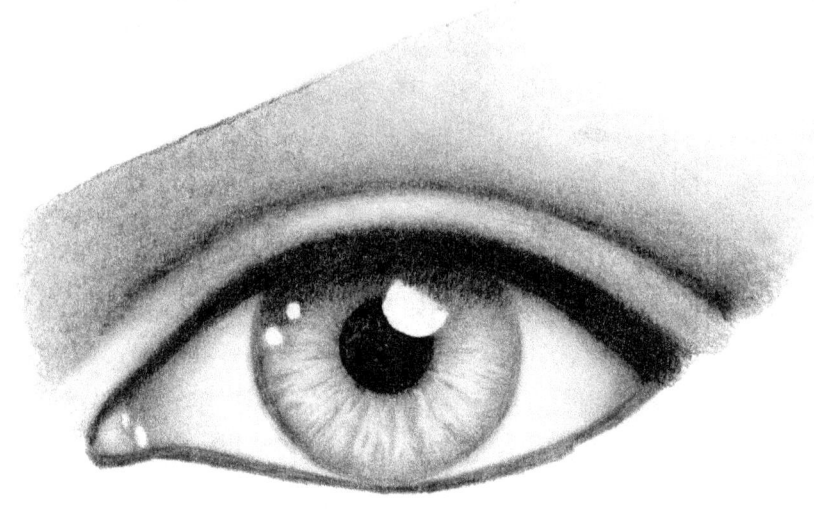

Leave the area right under the arch of the eyebrow for the brightest highlight. Shade it too with a 5H or 6H. It shouldn't stay absolutely white, but sometimes it is, when the skin is wet for example.

Press very lightly, as always when using 5H or 6H, and use circular motions here too. You can make your circles a bit bigger, not so tiny, so that it can be even brighter.

You can press normally next to the 2H area that we just drew, and release the pressure as you shade towards the eyebrow. This is a very

delicate part, so you should take your time for this. Blend this all with a tissue. After blending you can actually see how the tone appears. You can always go back and add more.

You take a look at your drawing in the mirror or upside down. Only then will you notice some mistakes and see whether your gradient transition is flawless. Just experiment with these things, and you can shade over and over again, and blend again, until you're happy with the gradient transition.

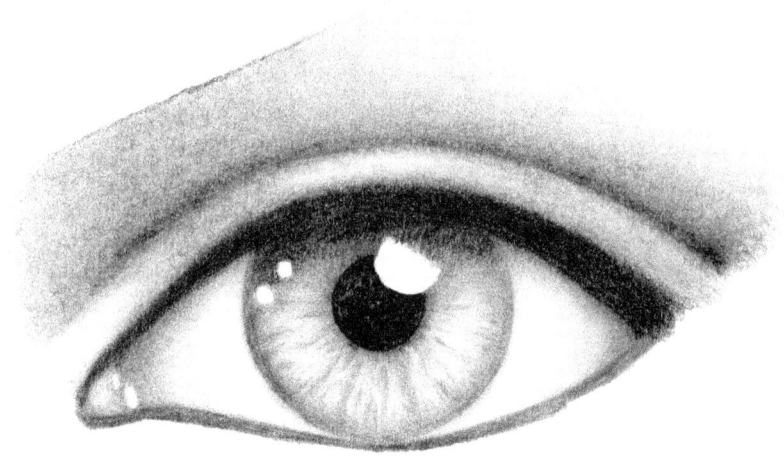

Here you can improve things before you draw eyebrows and eyelashes. You don't have to draw eyebrows, but I want to show you how to draw eyebrows too.

Shade the area of the eyebrows with a q-tip to add some kind of shadow, so that you won't place the lines directly over the white paper.

The skin under the eyebrow hairs will have some shadow cast by the hairs.

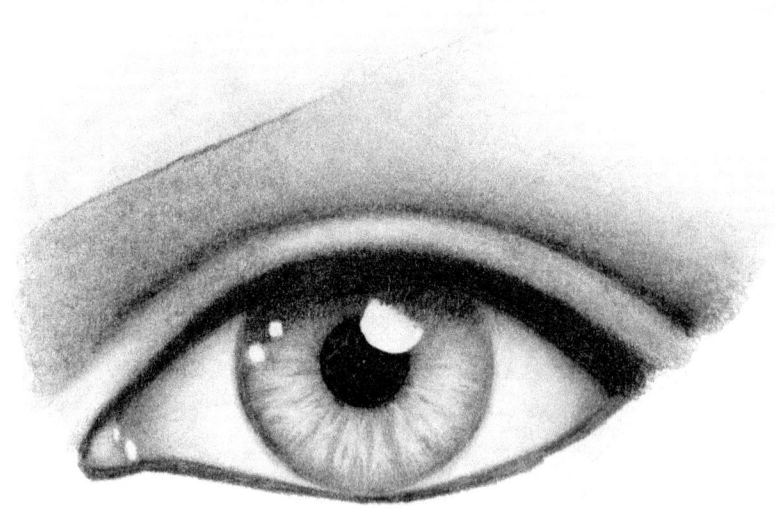

In the next image, you can see arrowed lines showing the direction of the hair growth, so refer to these directions all the time.

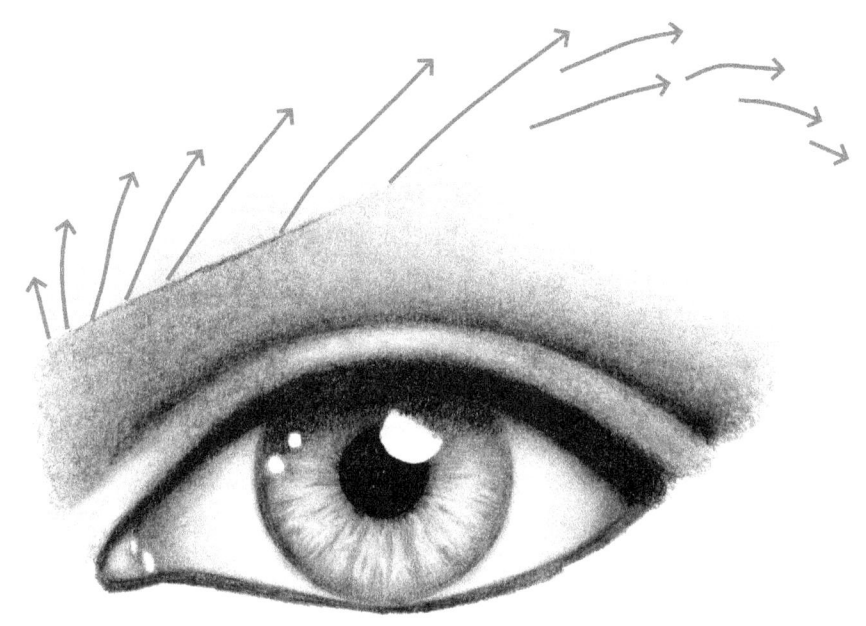

Start with a B pencil and draw on the lower area of the eyebrow, hair by hair following the direction of their growth.

This lower horizontal half area should be much darker than the upper area because it grows under the protruding frontal bone. You can even use a darker pencil, but I think a B is just enough.

You can add a few hairs with a 4B or darker to make them different.

In this step we are creating the darker parts. Blend the edge between the eyebrow and surrounding skin to make the eyebrows look softer. Make the hairs more horizontal as you draw towards the temple.

Draw the hairs with a B pencil on the right side, next to the temple. These hairs are almost horizontal, and they are much darker next to the temple.

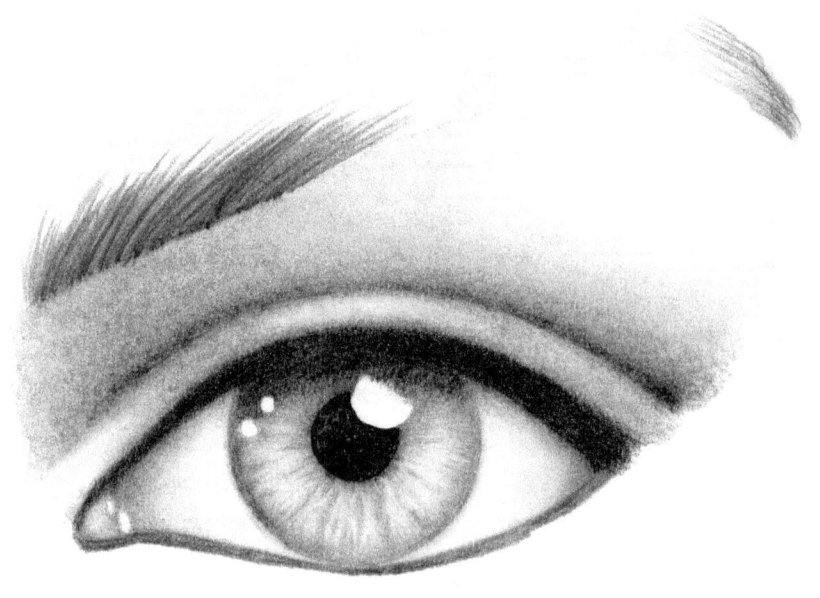

Now we can continue with an HB as a continuation to the hairs that we started with a B pencil. Draw the lines starting over the lines drawn with a B, pressing hard and releasing the pressure as you finish them on the top where the arrows are shown in tat image.

Also, press less and less as you draw towards the temple. Always change the pressure on the pencil to create some darker and some brighter hairs. Randomness is always good for realism.
Skip only the area over the most highlighted part – as shown in the next image.

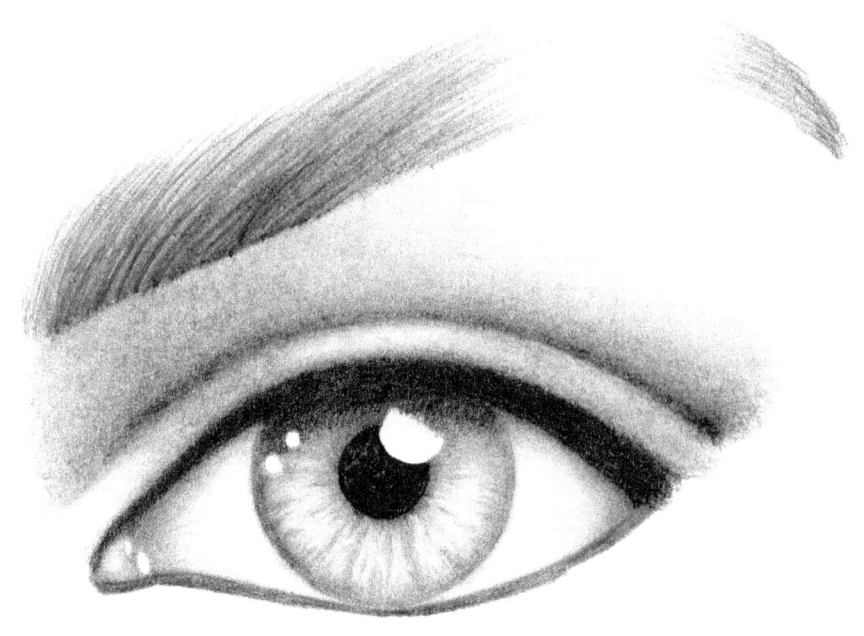

Cover the highlighted area with a 2H, following the direction of the hairs growth.

The hairs are highlighted over this protruding part, same as the skin. Now the eyebrow also suggests the roundness of this part of the head, not only the skin.

Use an eraser to create some highlighted hairs.

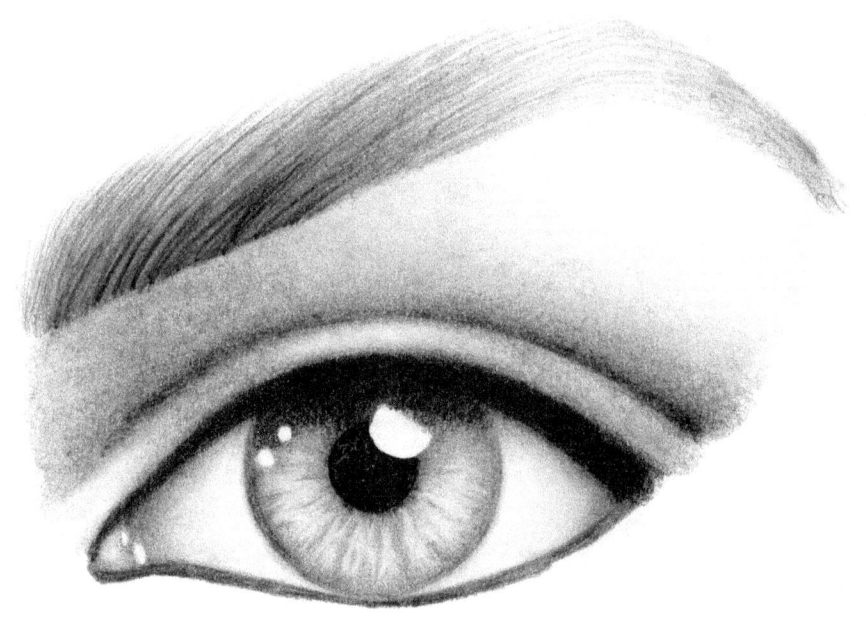

Before you apply the eyelashes, make all the changes that you want.

And now we can finally draw eyelashes in the direction of the arrowed lines shown in the next image, so refer to this image while drawing eyelashes.

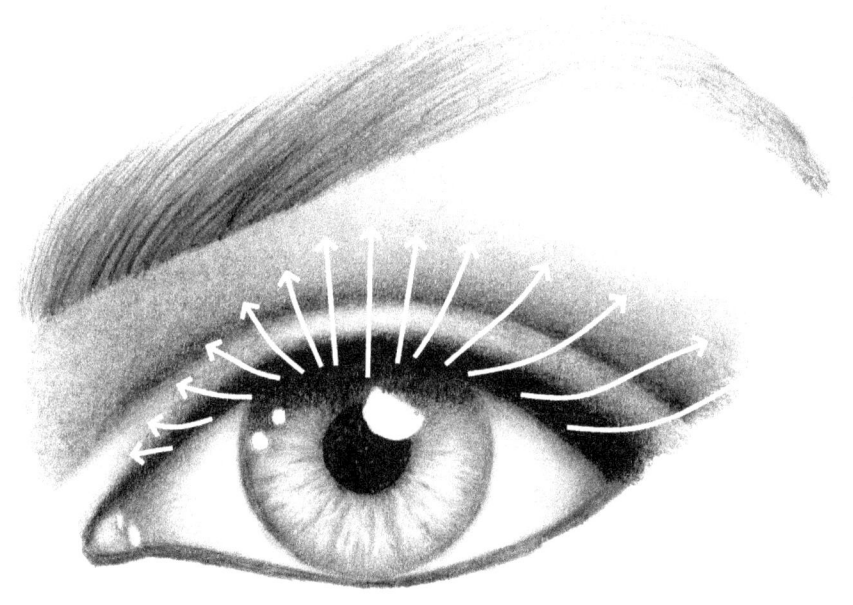

Start in the center, above the iris. Here you have to draw vertical lines only. I'm using an 8B pencil with a very dull point.

Create some shorter lines too and make some of the hairs stick together. That will particularly

happen if a person is wearing mascara.

Don't make these hairs straight, but rather a bit curvy, yet not as curvy as they are on the left and the right sides.

Also, don't make them the same size in the same direction just at random some of them should be pretty short and some of them should be quite longer

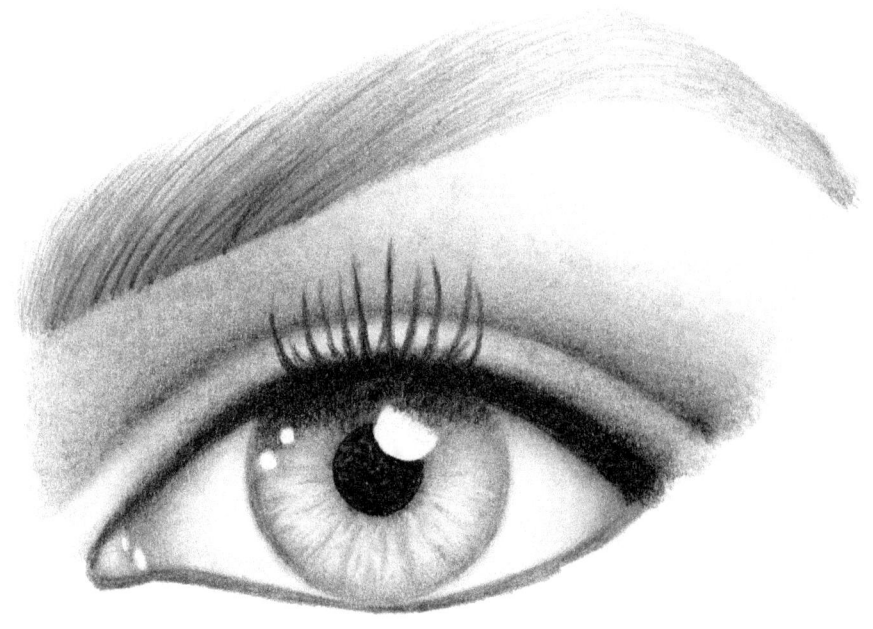

As you go towards the left corner, make them more curved, tinier, thinner and shorter.

Start drawing almost horizontal lines next to the tear duct.

As you could see in that image with the arrowed lines, they should be less dense. Draw them just a bit over the sclera, downwards, make a curved line downwards and just turn it almost horizontal. You can use a B pencil because these eyelashes are not that dark.

Draw them at random, don't make them all the same. Blend them a bit over the sclera, with a blending stump to create a stronger cast shadow.

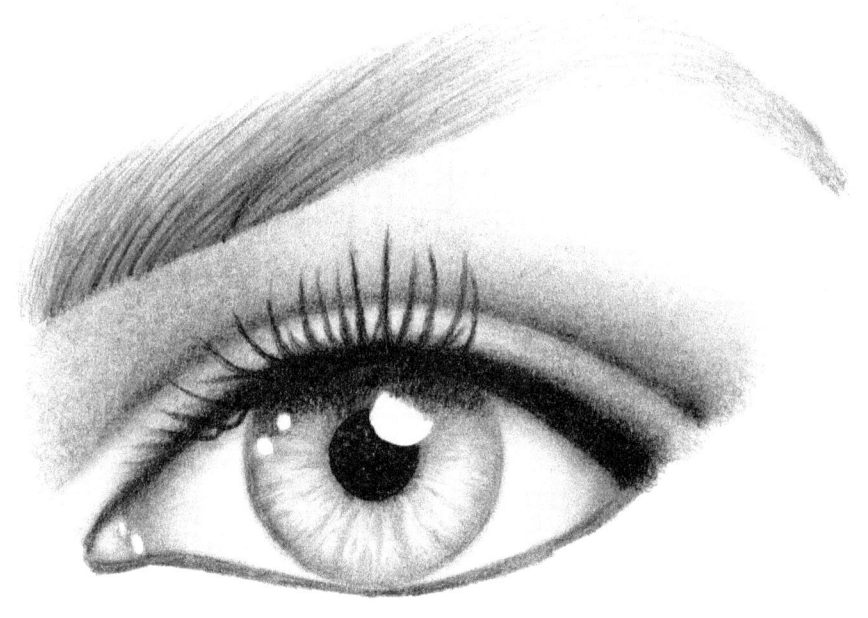

Continue drawing the eyelashes on the right side. These eyelashes also become more and more curved as we draw them towards the right corner of the eye, and they become thicker and thicker, longer and longer, and also denser and denser. Use the dull tip of an 8B pencil and press very hard. Go a bit downwards, then turn towards the temple and finish the longer part of the eyelashes. We should have short hairs too that just go downwards, over the sclera, and everywhere, so draw them too. If you want longer eyelashes, just shade a larger area so that it won't go over the unshaded paper. So, make them very long on the very right side.

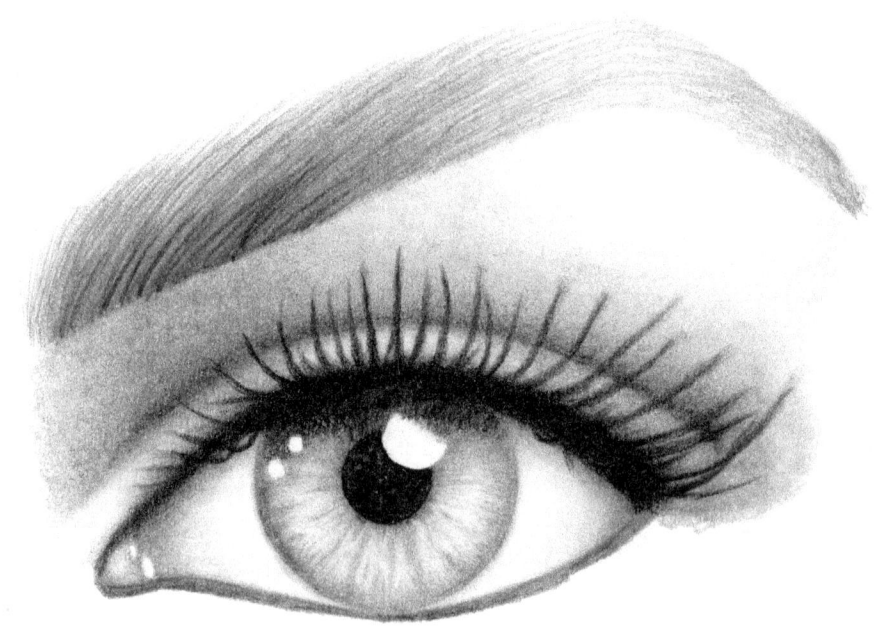

Draw the area under the eye too, so that you can apply eyelashes over it. I'm using an HB and I want this area to also have a little bit of makeup. As I mentioned, it's easier to create a darker drawing, it looks better and it's more difficult to draw a lighter drawing. Keep applying circular motion and cover this area. This part actually also gets less light, but of course it depends on the light source. It can be more illuminated too, so you can see now how the whites of the eye, the sclera, becomes better and better and more real as we draw the surrounding areas. Now you can see the depth in the eye due to the gradient transition. Blend it with a Q-tip to make it look much smoother and better.

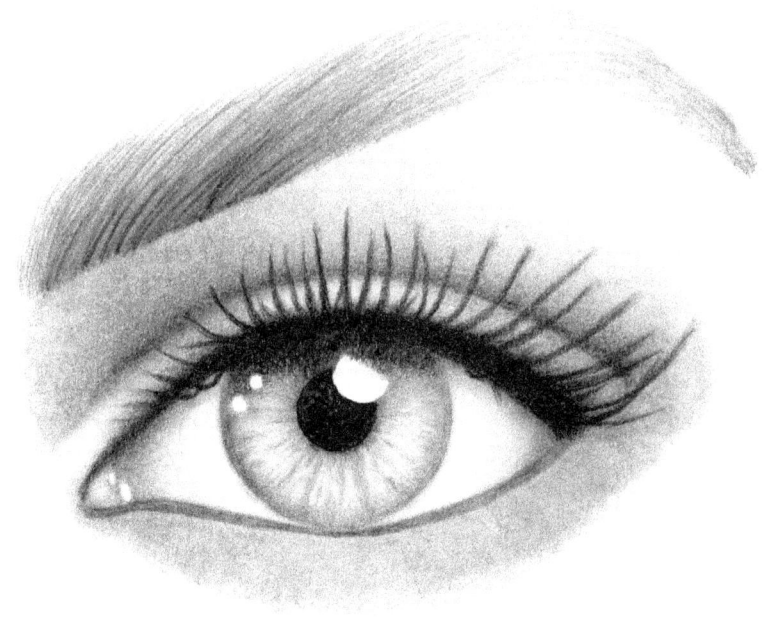

Now we can shade a bit more all around, to create the brighter skin.

Use a 5H or you can just blend it with a tissue. Press harder next to the HB area, and release the pressure as you go downwards. Just use circular motions.

You can see that throughout this whole drawing, I'm referring now to the skin part, that using a circular motion is very beneficial. If someone tells you to use a crosshatch pattern or parallel lines, I think you shouldn't because I do know that those techniques won't create the smooth texture you want for photo realism. But not everybody wants to draw realistically.

Some people want to have those cross hatches visible. I suppose that you want to draw it like me, so if you want to make it smooth like this, then circular motions are a solution and the best way to achieve it.

Even if you have some parts of these tiny circles visible, it's good because the skin is not perfectly smooth. It does have some imperfections on it: tiny wrinkles, hairs, scars, moles and so on. The skin under the tear duct is pretty highlighted, it's illuminated pretty much in any circumstance, so we should keep it very bright and ,of course, blend it with a tissue once you finish.

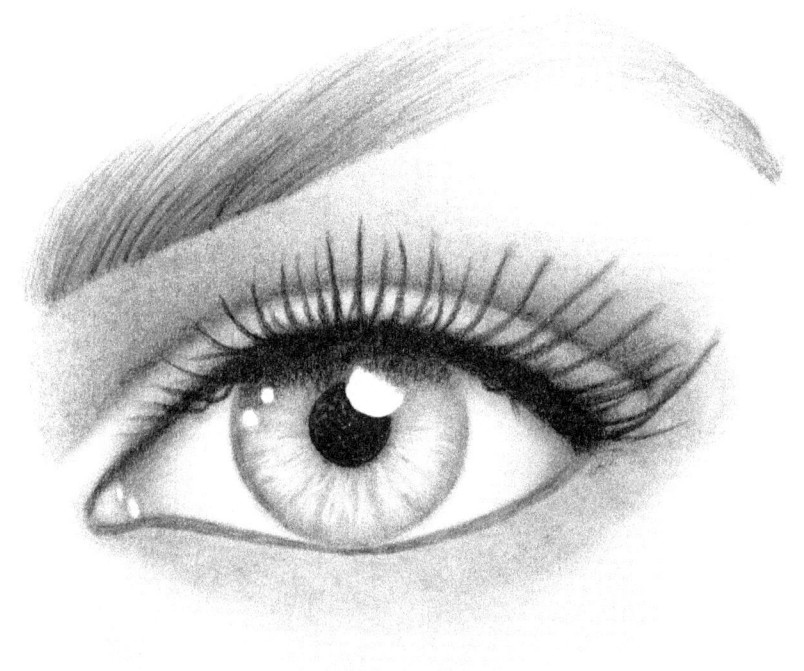

Let's fix up the shape of this protruding area under the lower eyelid, the self shadow under that circular muscle that goes all around the eyeball. Keep using circular motions and a B pencil.

The area in the middle should stay highlighted, so we have to draw under that. This is a so-called self-shadow. So, shade on the right and the left sides and under the mid area and blend it with a Q-tip.

In the next image, you can see how it got its shape. Shade more under the eyelashes on the right side. They will cast shadow, so press harder there.

Also, using a B pencil, shade more under the roots of the eyelashes to enhance the edge between the thickness of this skin and the skin.

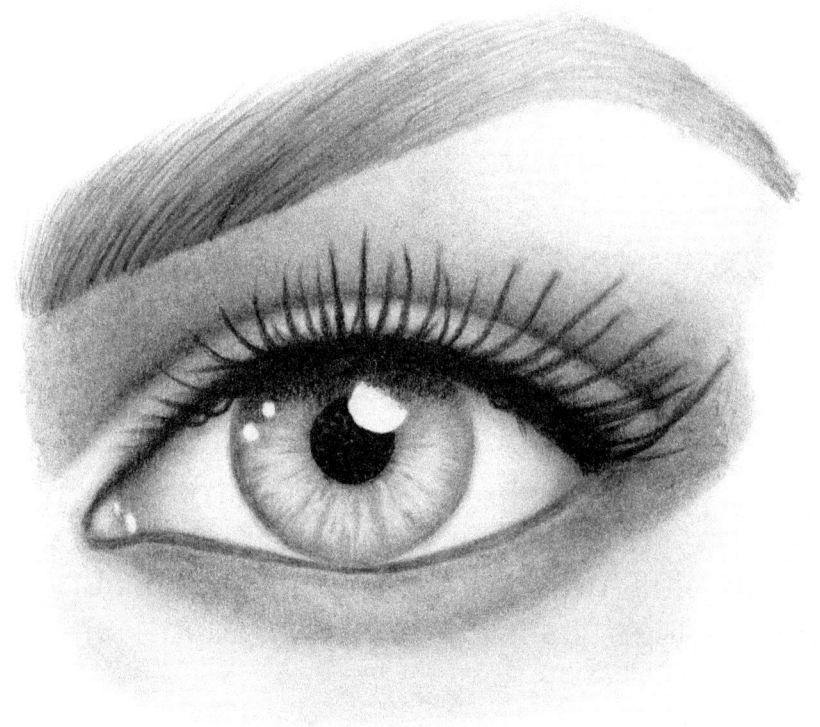

We used an 8B for the upper eyelashes, but here a B is pretty good. It's still dark enough.

Draw the eyelashes under the thickness of the skin. Connect the ends of some neighboring eyelashes, and draw them vertically in the middle, the same was with the upper eyelashes. Draw them smaller and smaller as you draw them towards the tear duct. Some of them grow farther under this edge, so just take care to draw those too. Here we have very short and tiny eyelashes that are just hardly visible, but draw them too pressing lightly. As you draw them towards the right corner, start to draw longer, thicker and denser eyelashes. You can even start using a 4B or darker pencil here and connect their ends in some areas.

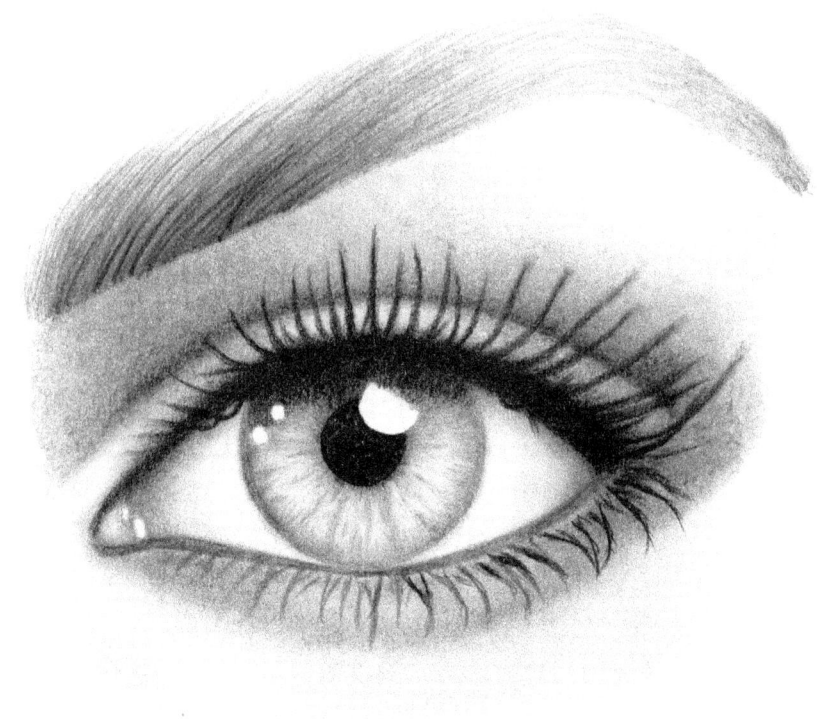

Since we have the whole picture done, we can add some finishing touches. For example, we can add some highlights with an eraser or a white marker.

Create some more highlights over the edge between the thickness of the skin and skin under it, in between the roots of the lower eyelashes. This edge is often wet, so just stipple with the tip of your eraser to pick up a bit of the graphite. You should create a lot of highlights because the eye is wet and we have to suggest that by highlighting it. Compare the previous and the next, final image to see the difference and what I have exactly added.

So, create tiny, white dots where they are supposed to be. Also, add some wrinkles with a 2H or brighter pencil.

When you use a white marker by Uni Posca, and you don't like what you have drawn with it, you can always remove that with your nail or tip of some bright pencil when the markers dried up. So, just use this marker bravely because it will make your drawing much better and more realistic. I'm not sure about other brands because I haven't used any, but these markers by Uni Posca definitely work this way. I often apply them over my colored pencil drawings too.

If you want it to be less bright and make its edge blurrier, just tap on it with your finger before it dries up. Experiment with this tool to see what it can do. Strengthen the highlights and shadows wherever you want.

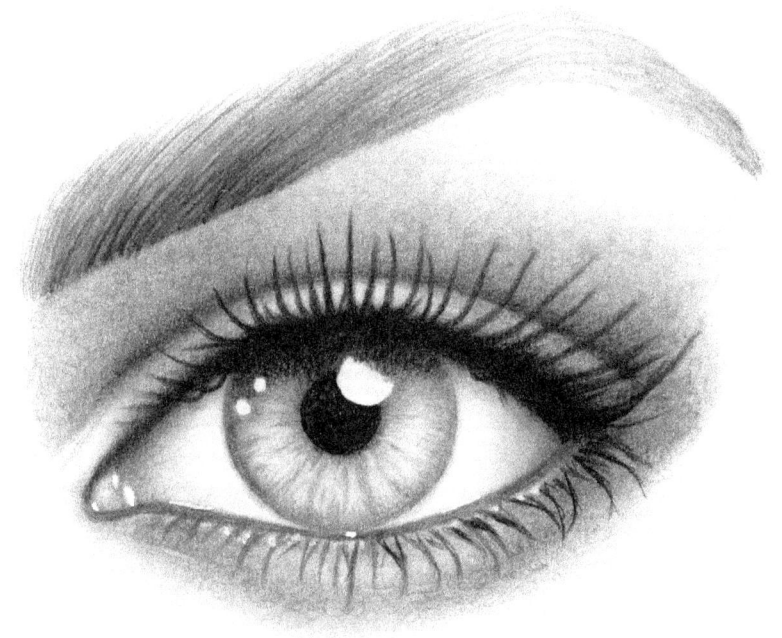

About the Author

Jasmina Susak is a self-taught, graphite and colored pencil artist, art teacher and author of more than 17 how-to-draw books. She specializes in creating photorealistic drawings of animals, people, superheroes and everyday objects.

Jasmina graduated and worked as a dressmaker for many years. Now she is a freelance, self-employed artist. It is her full-time job, and she's been doing it professionally since 2011.

Jasmina has hundreds of thousands of followers and subscribers on social media, and her drawing videos have tens of millions of views all around the world.

Jasmina loves animals, science, astronomy, technology, web designing, reading, listening to music.

Visit her website for more tutorials, her drawing gallery, art prints and more.

www.jasminasusak.com

If you want to learn faster and better, I recommend joining my website, **Pencil Drawing Tutor**. As a member, you'll learn through real-time narrated videos, step-by-step written tutorials with pictures, and have 24/7 access to **PenPick Graphite**. You can attach your drawings under any tutorial and chat with other members. The lessons are perfect for beginners, those looking to improve, or anyone who wants inspiration and fun.

Brand new tutorial every WEEK.
Come join us!

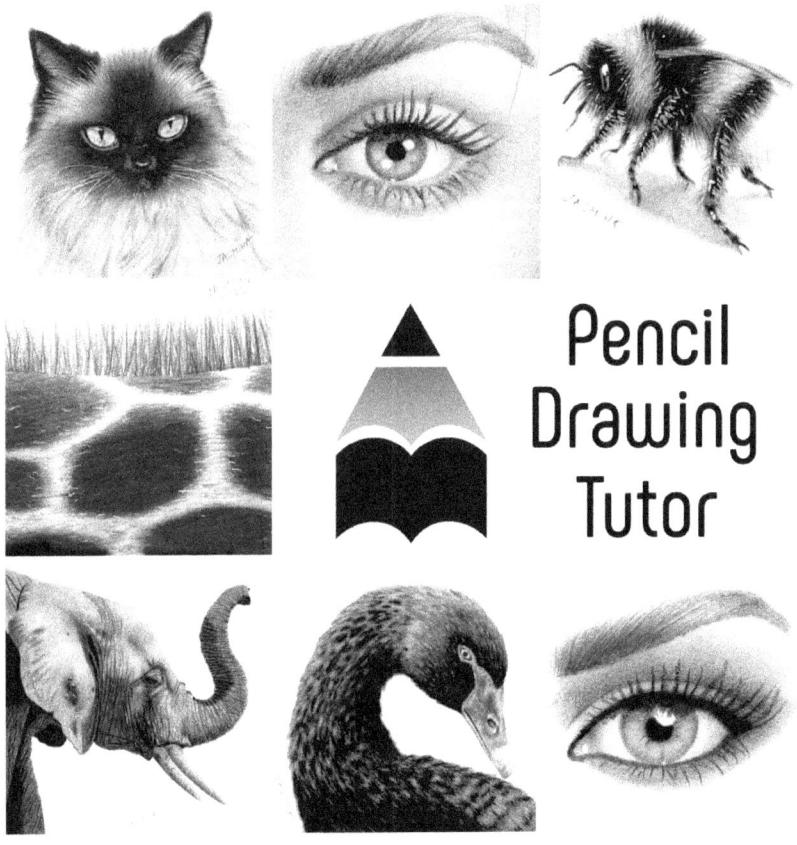

WWW.PENCILDRAWINGTUTOR.COM

www.ingramcontent.com/pod-product-compliance
Lightning Source LLC
Chambersburg PA
CBHW072245170526
45158CB00003BA/1006